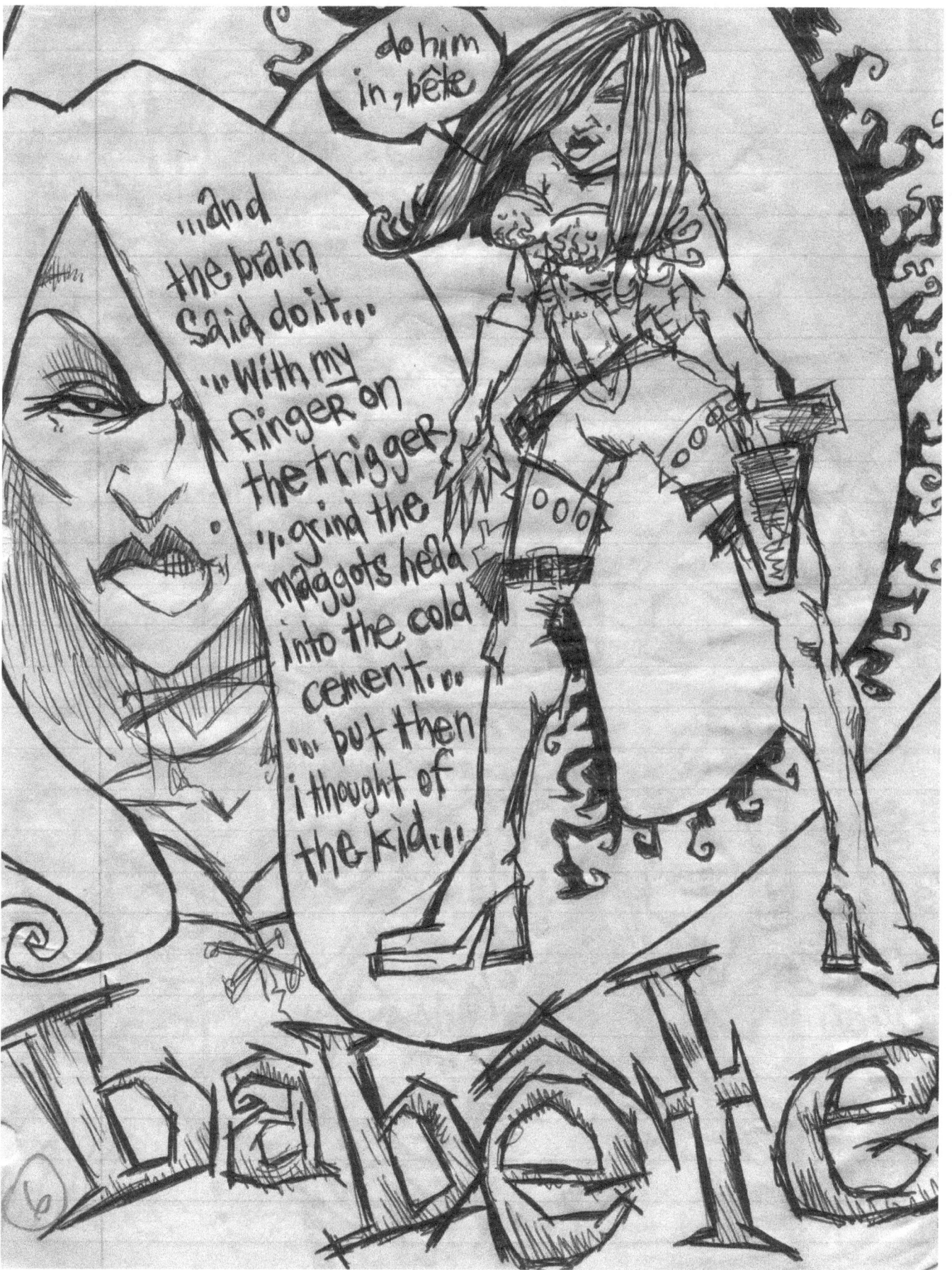

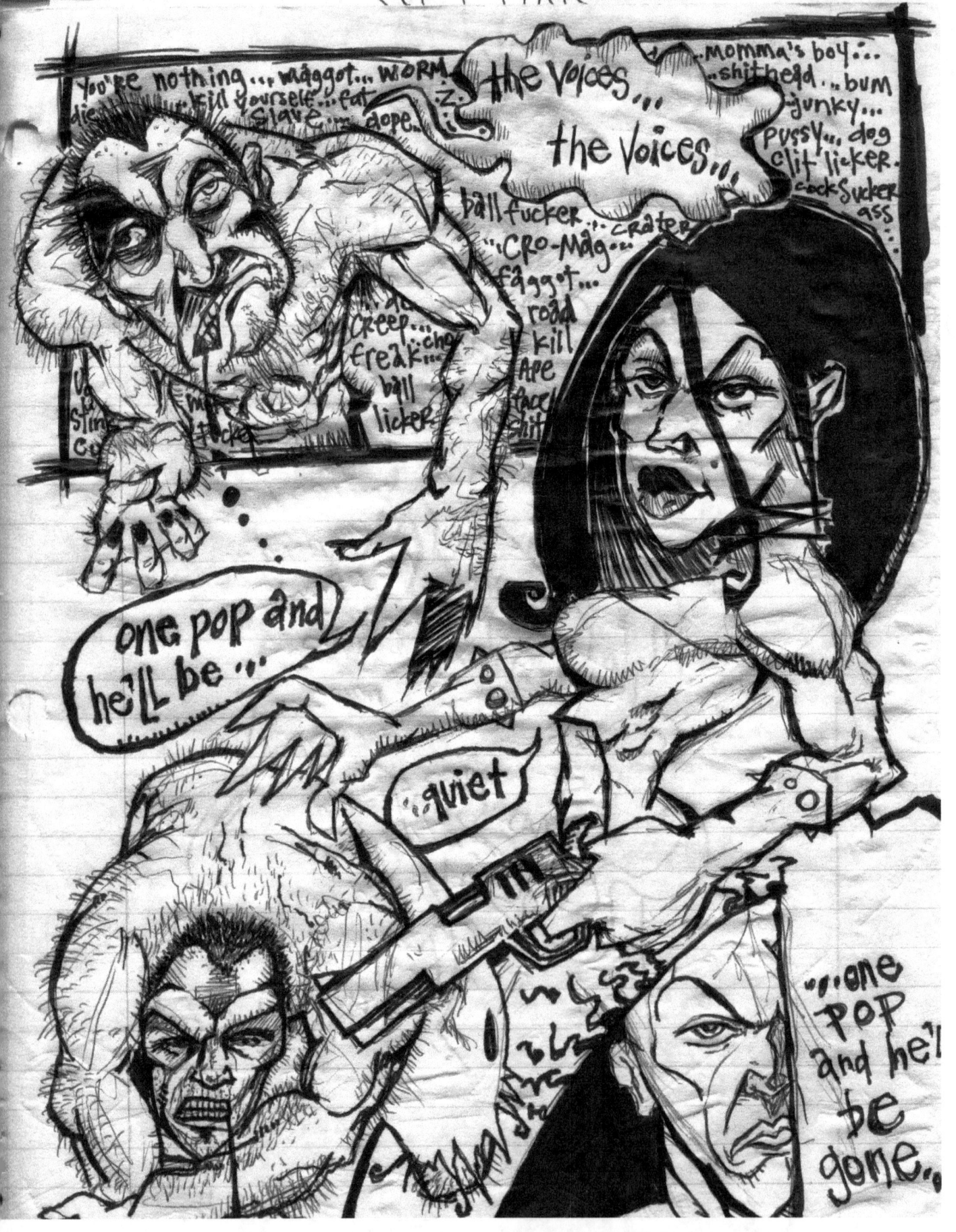

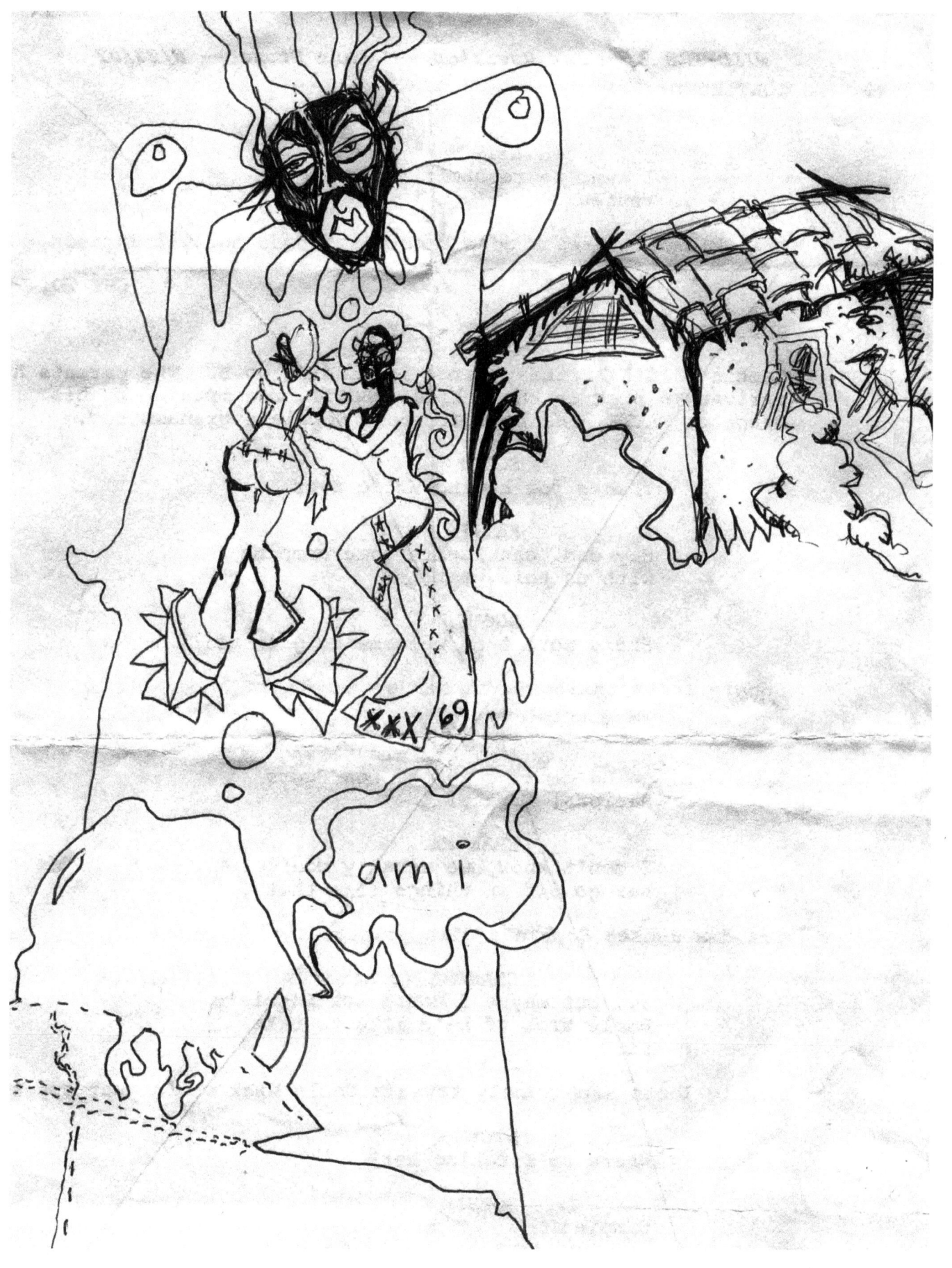

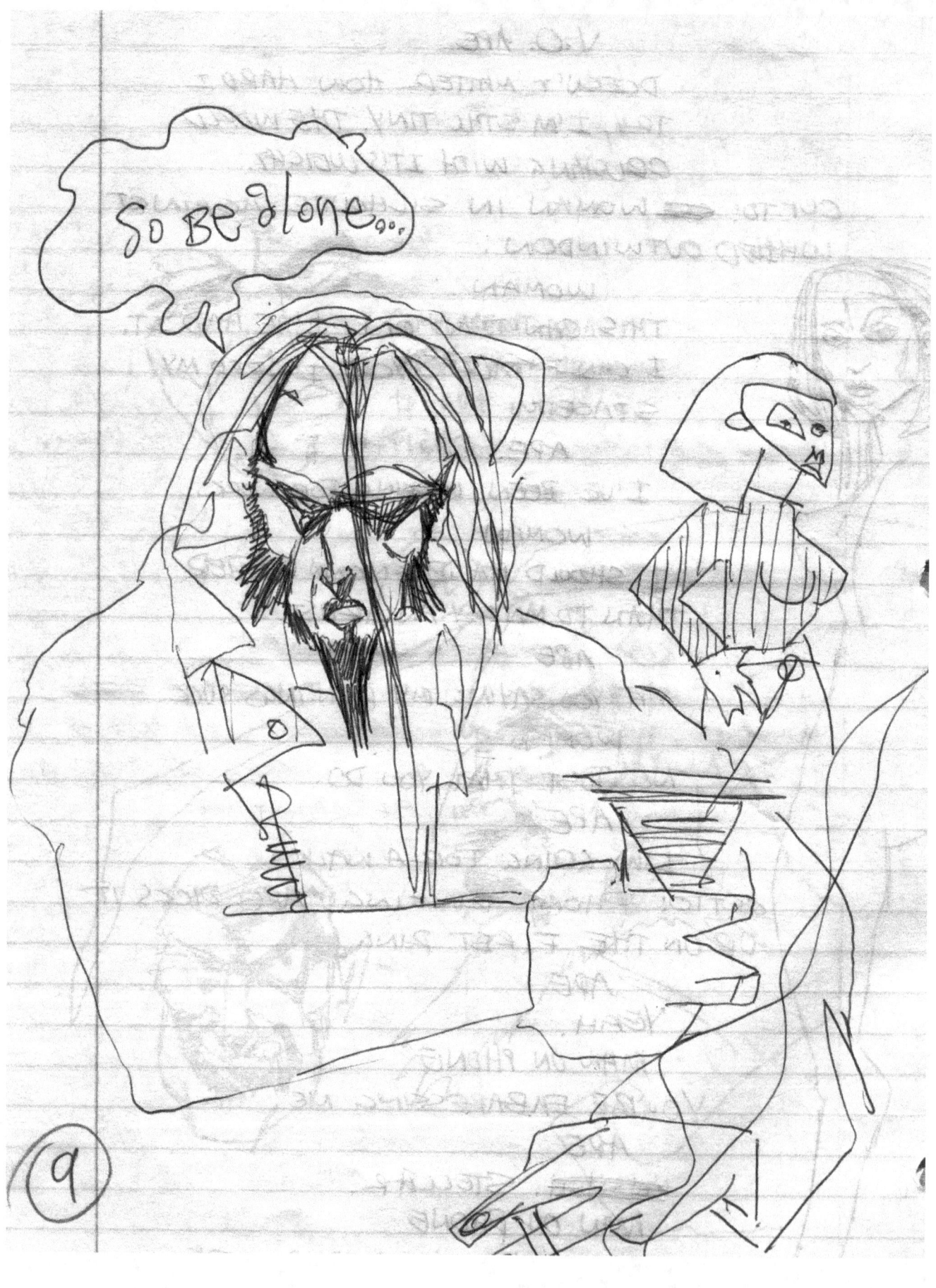

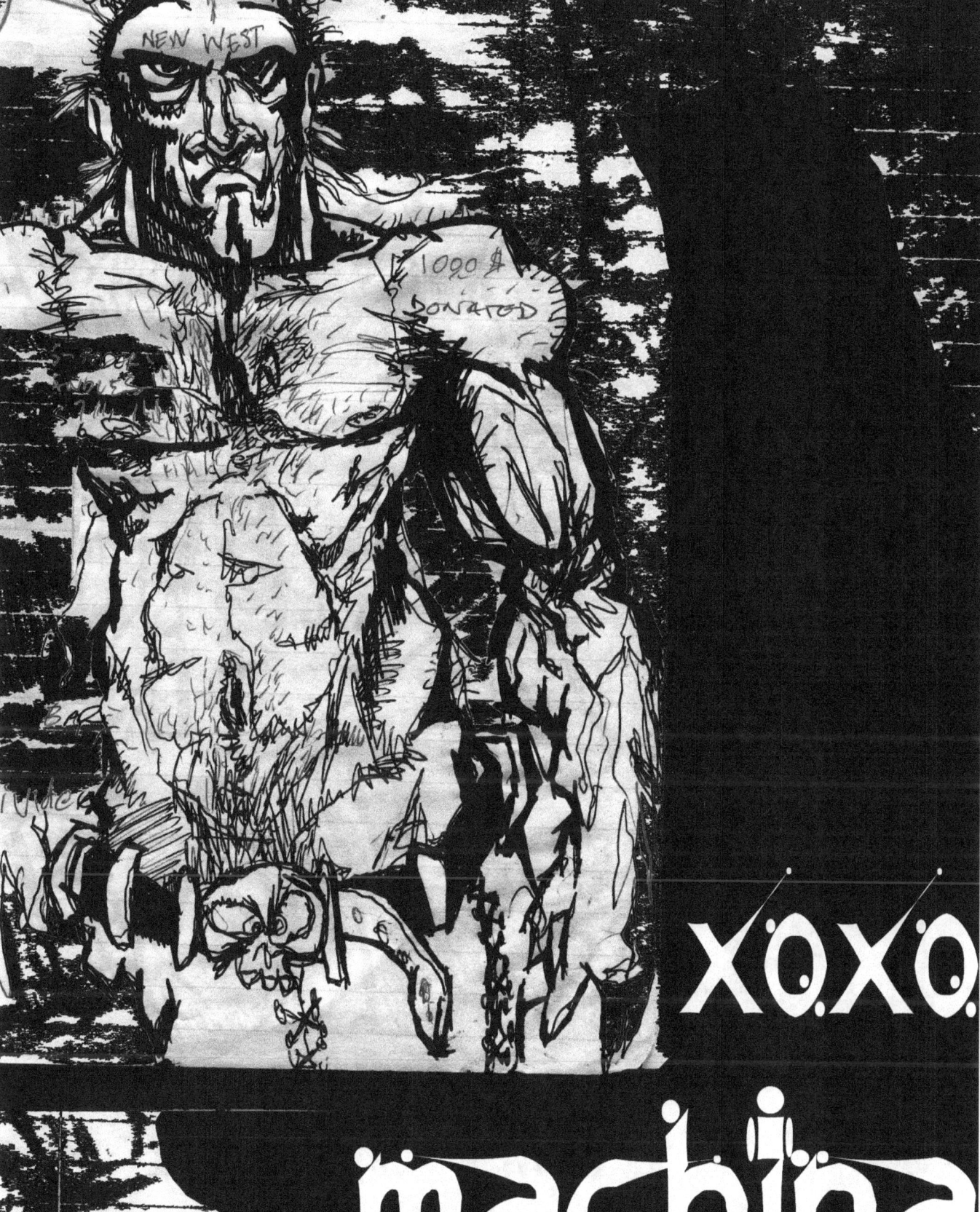

"Ain't got nothin' but time... Tick tock, tick tock.

You may be pretty, but you're ugly on the inside."

DEFEYE

DEFY × DEIFY

DEF EYE

"AUDIENCE FOR YOUR LUNACY."

A.K.'14

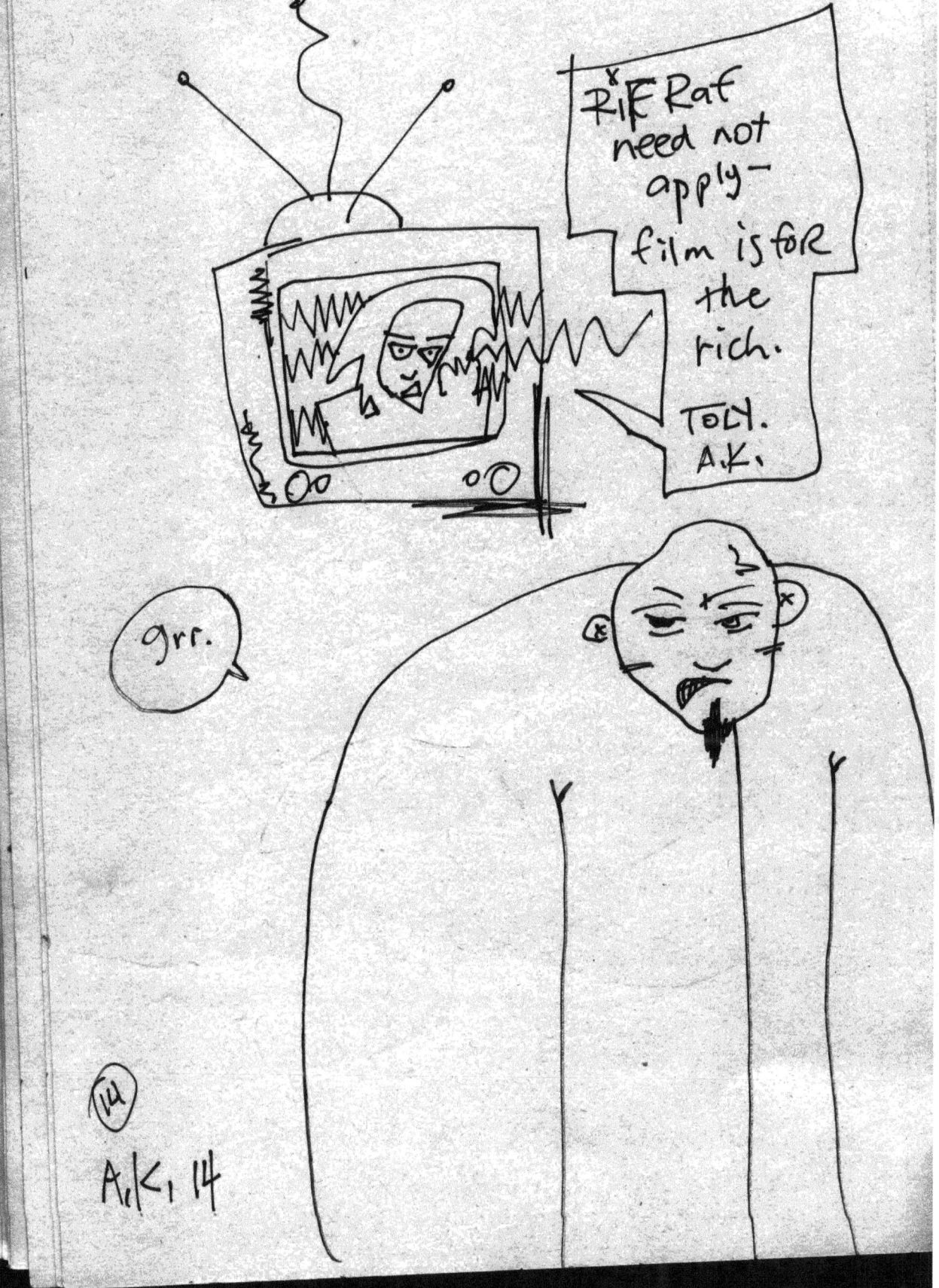

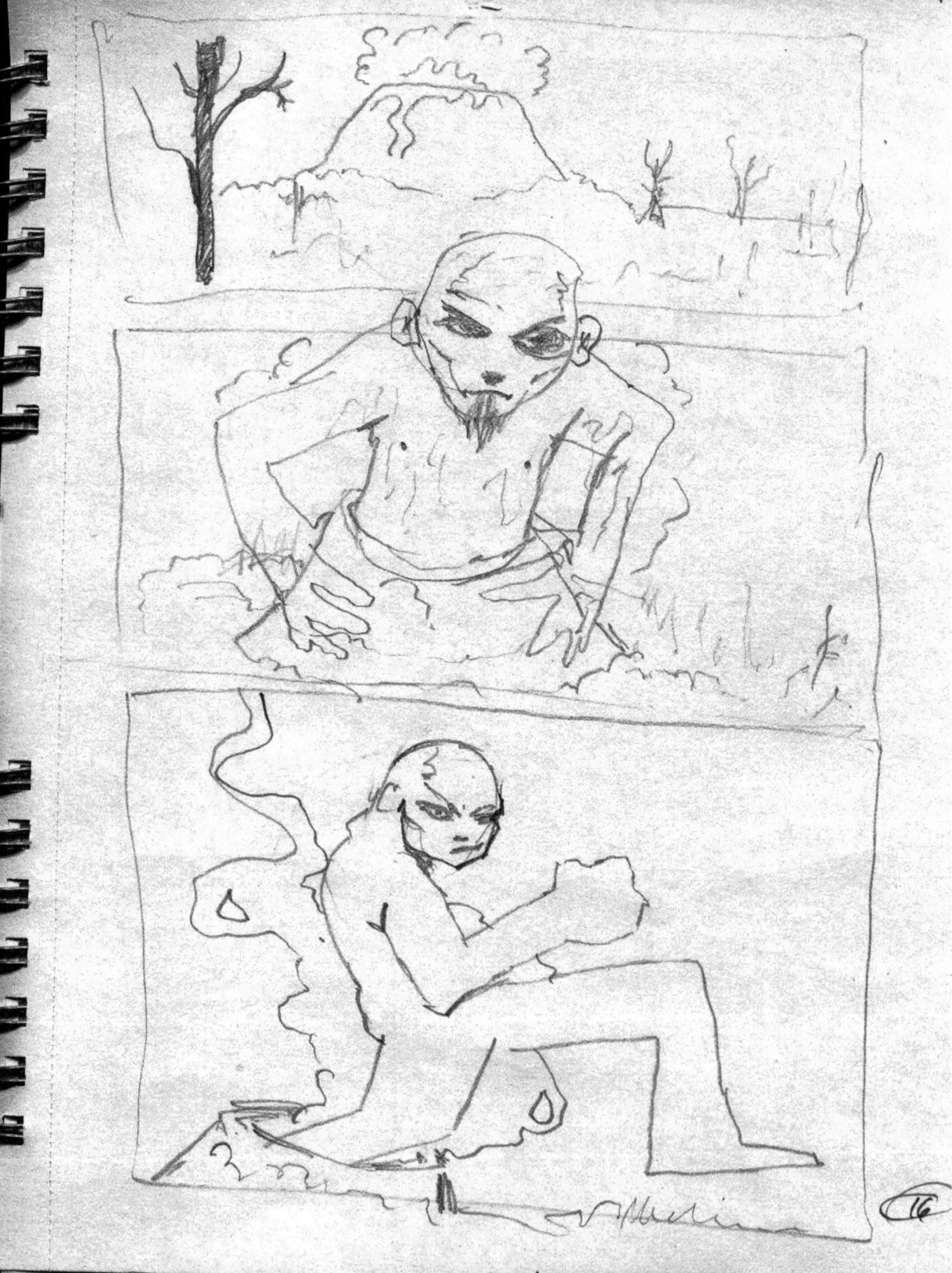

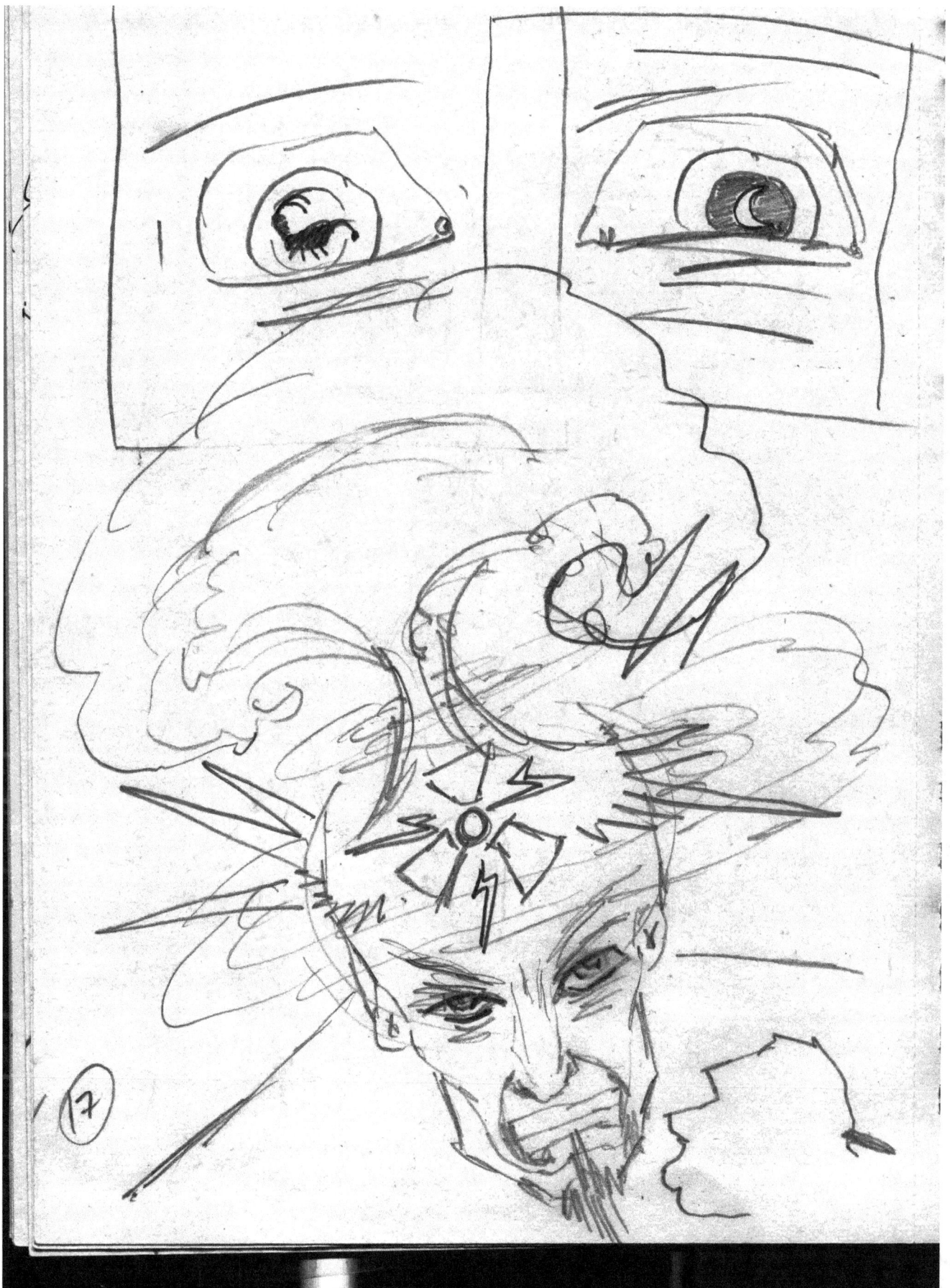

...Doomsday.

Planet under Siege

Judgment day!

TOLY A.K. 2014

As Martians invade a serial killer remains at large...

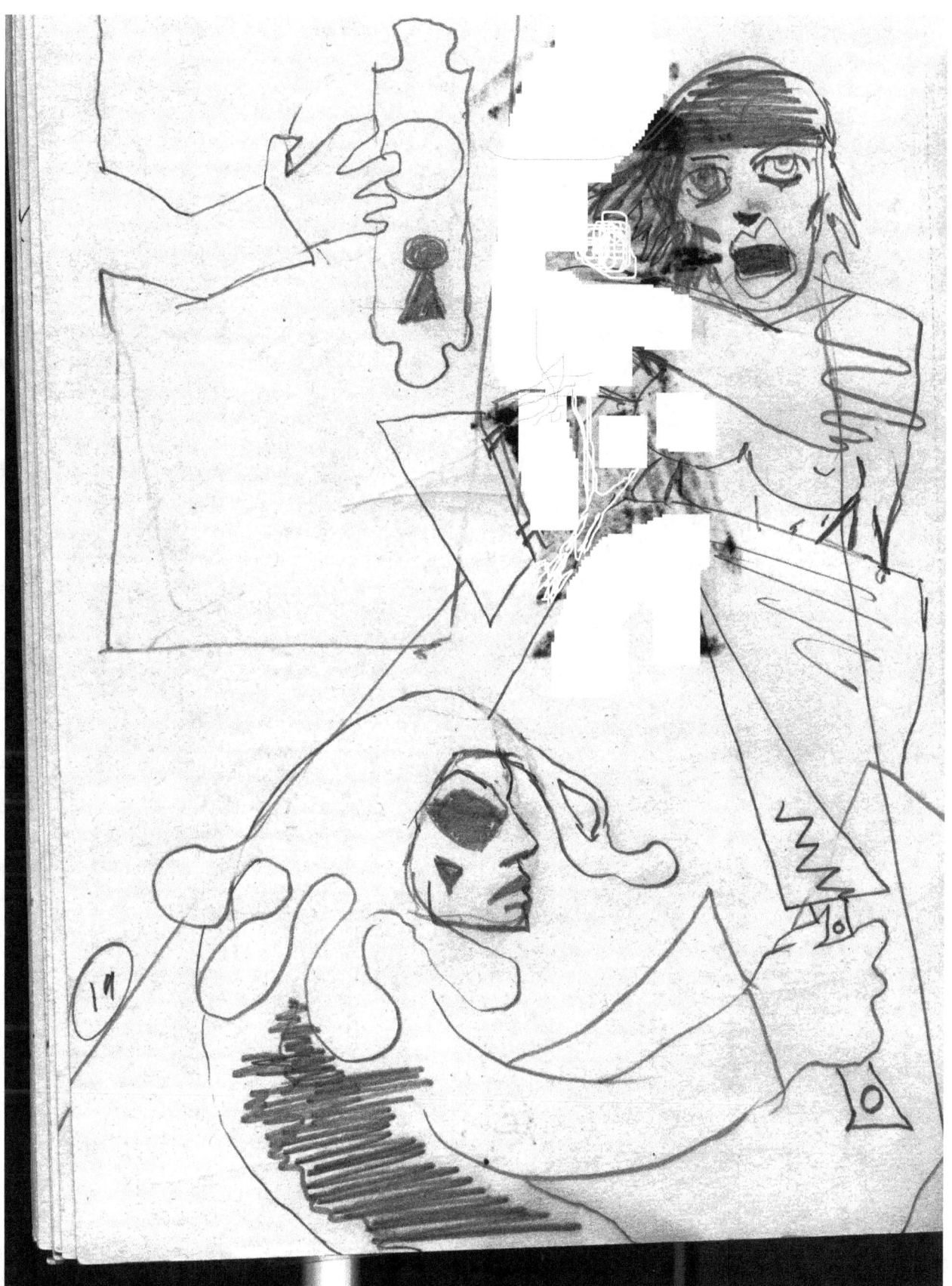

"I'M GOING TO GET A JOB, OH, WHAT I DO SO IMPORTANT I DON'T HAVE ANY ANSWERS WHEN SOMEONE TELLS ME THEY DO, I LOOK THE OTHER WAY."

you taste like fear...

What the?

You staste like love...

but you smell like fear

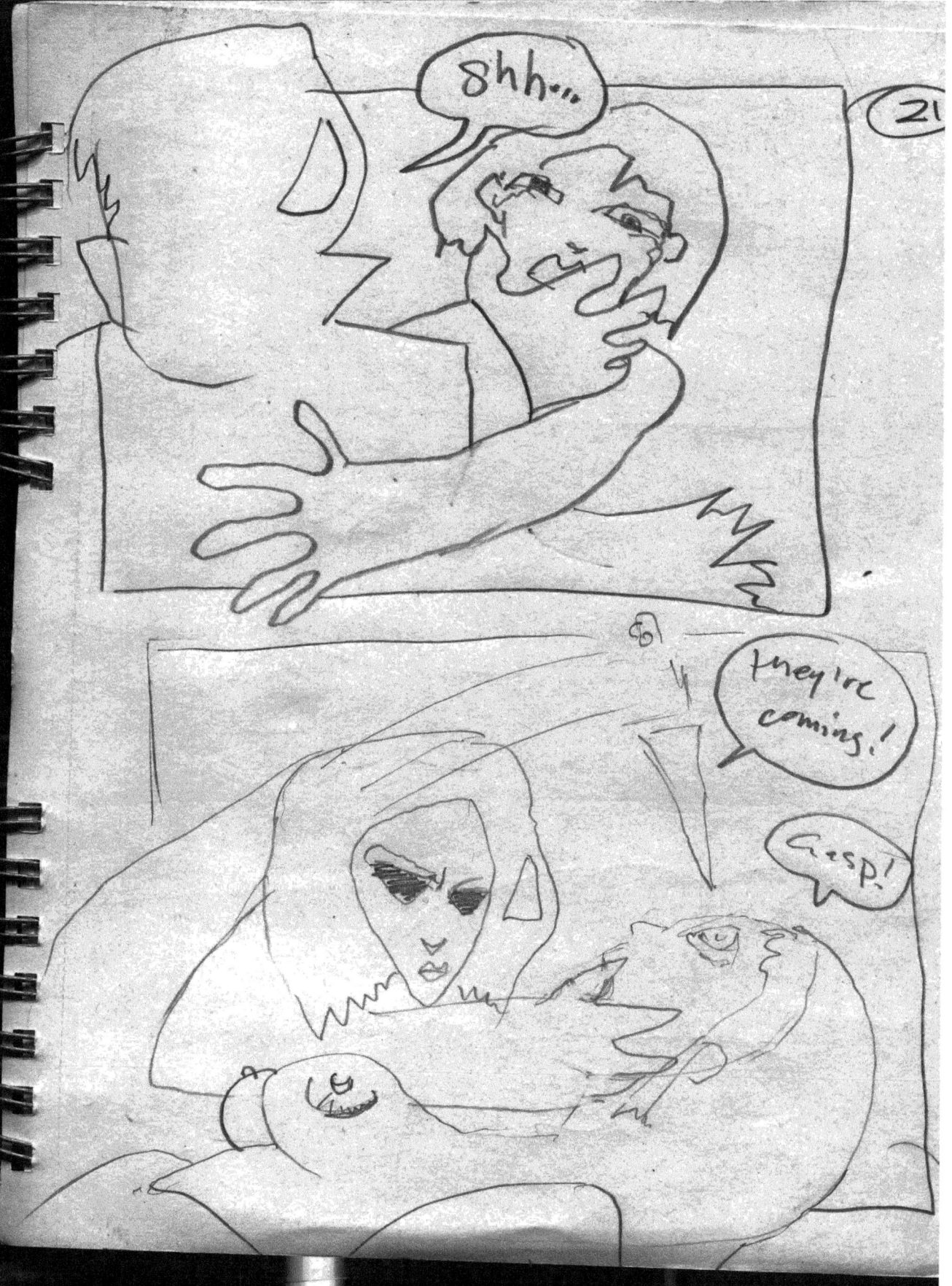

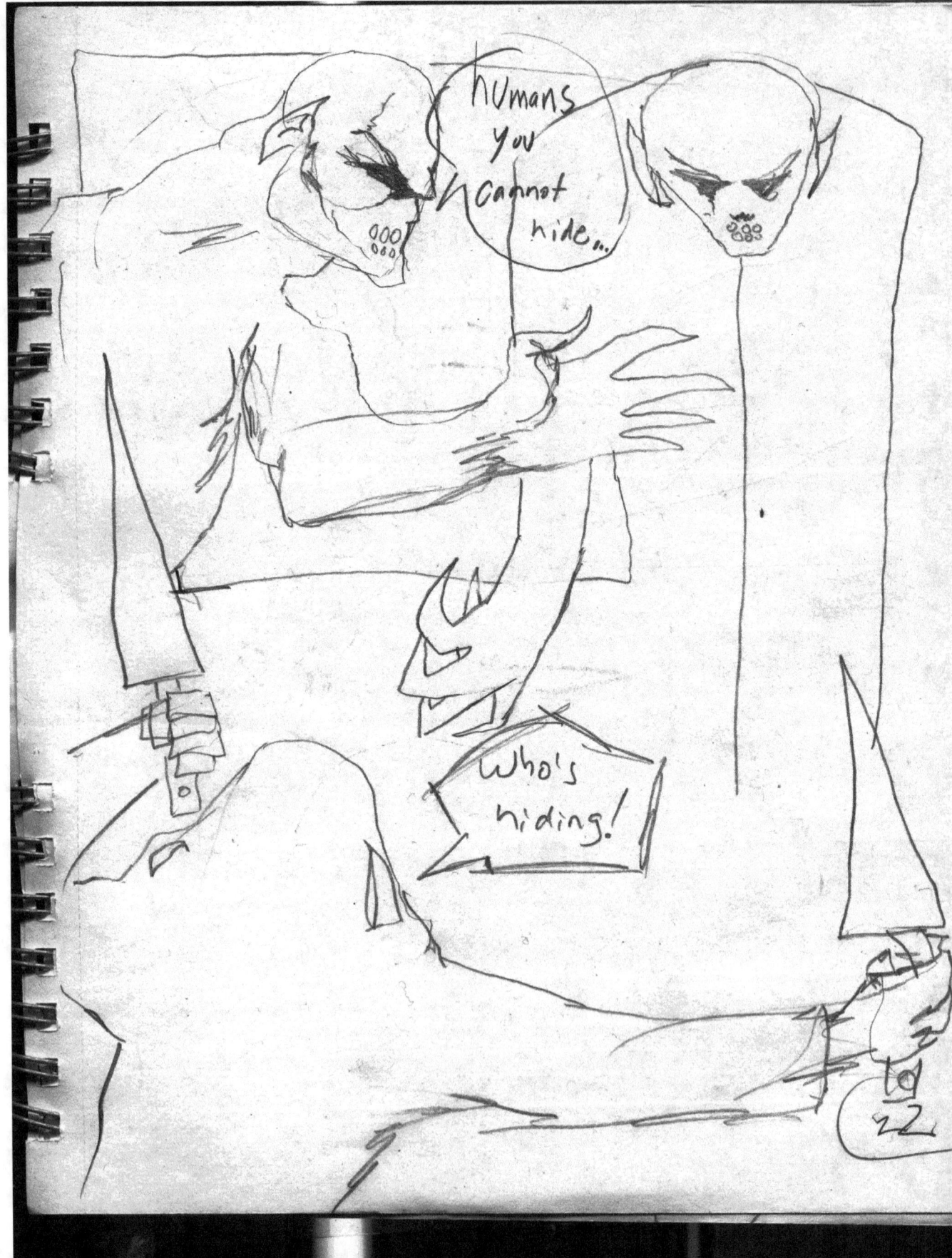

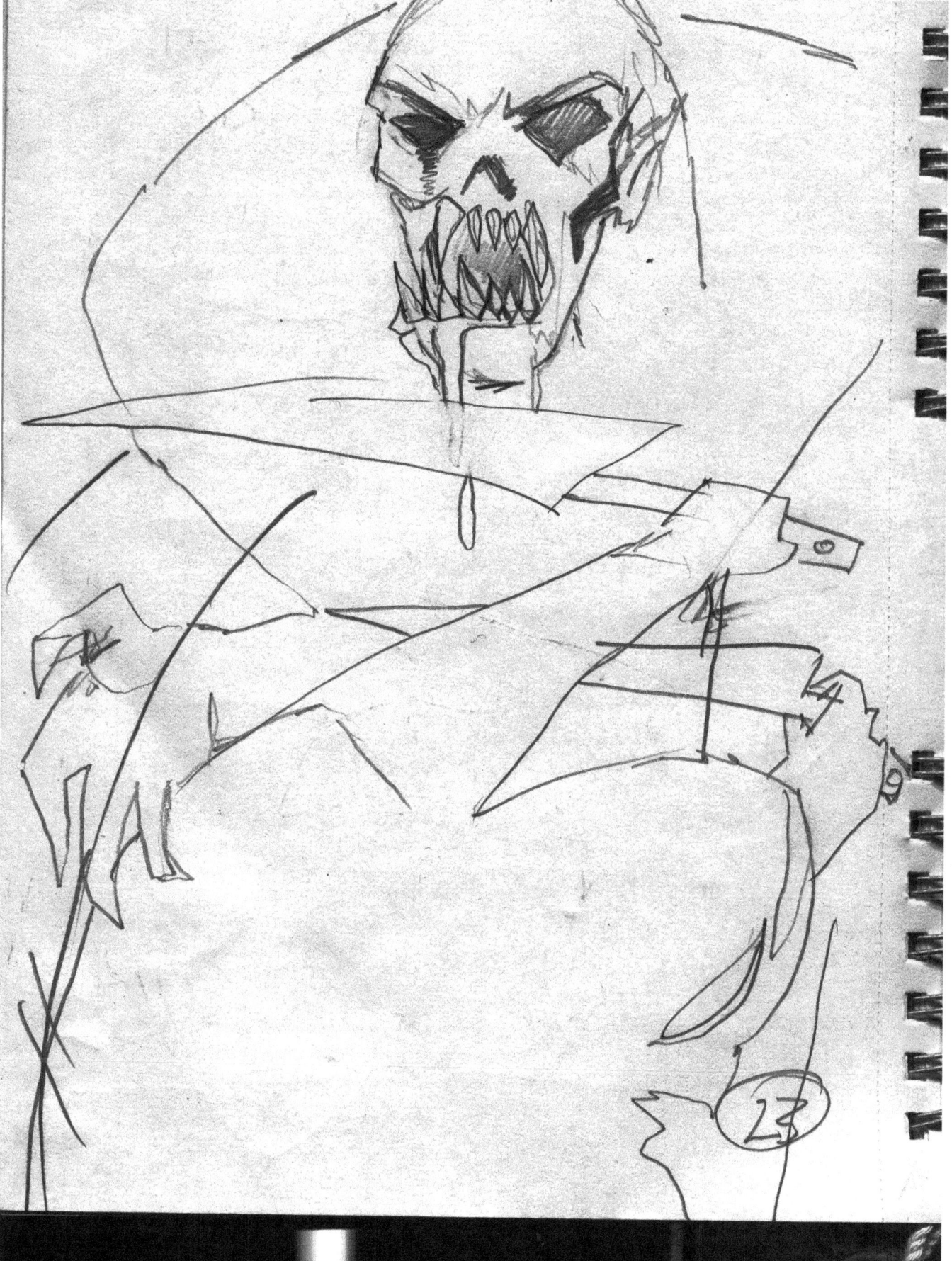

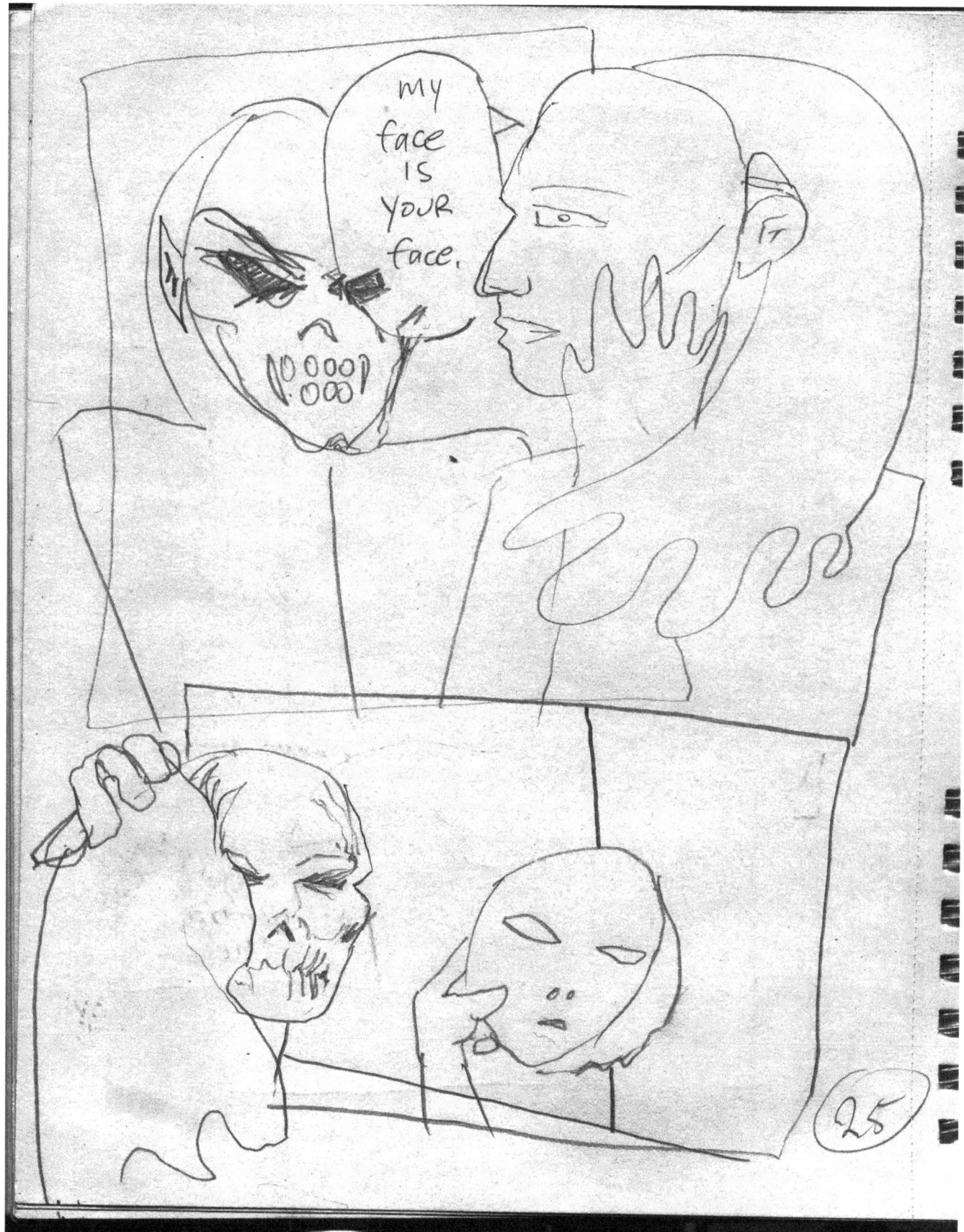

"I smell death."

Four score and seven years ago — 7 beasts barked a veil of lunacy of a 1000 dead souls rising to claim the earth. Vindication is theirs.

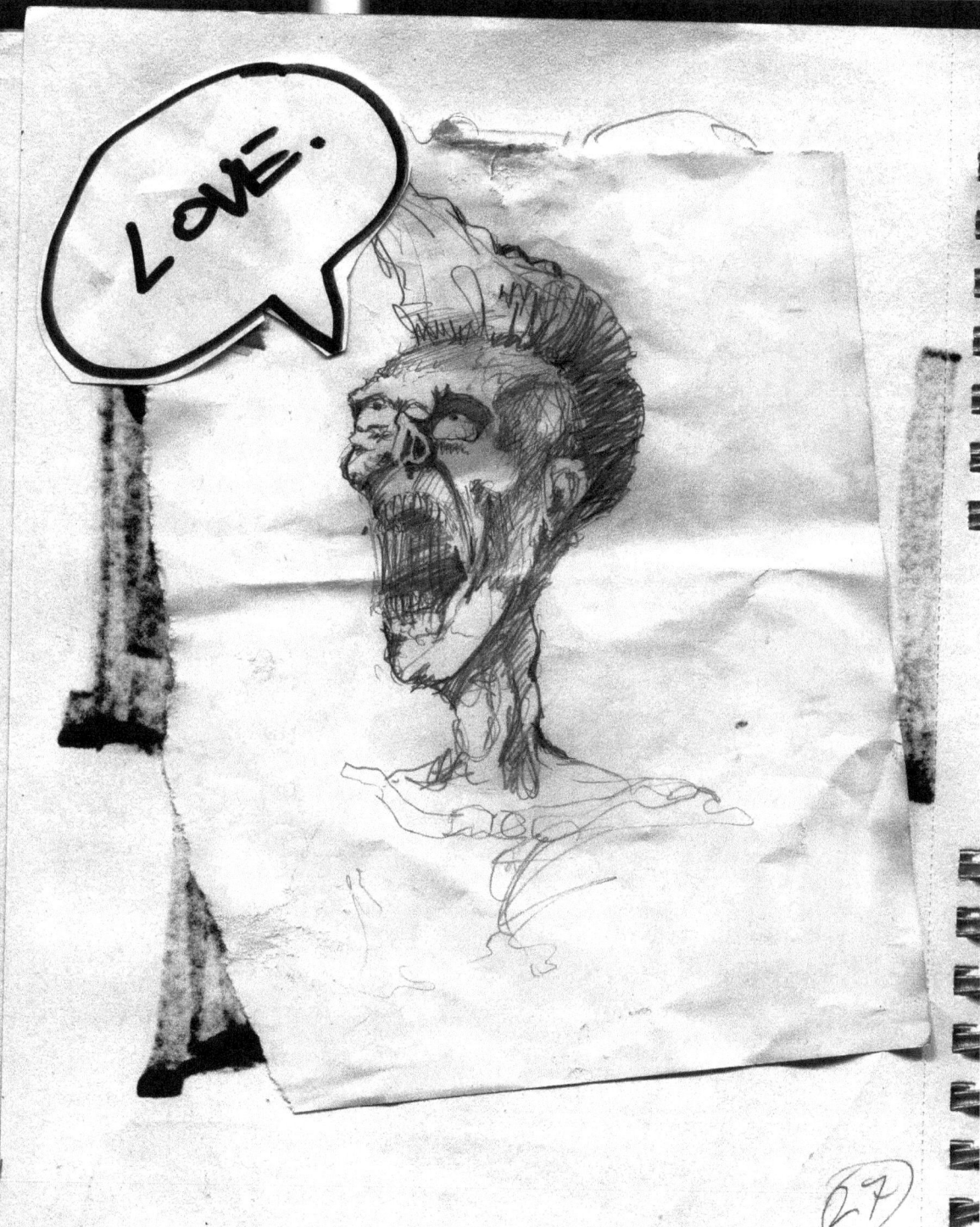

www.ingramcontent.com/pod-product-compliance
Lightning Source LLC
Chambersburg PA
CBHW081819170526
45167CB00008B/3464